IDEAS HAVE LEGS

First published 2006

Murray & Sorrell FUEL ©
Design & Publishing
33 Fournier Street
London E1 6QE

www.fuel-design.com

Printed in Hong Kong

Distributed by Thames & Hudson / D.A.P.
ISBN 978-0-9550061-5-9

IDEAS HAVE LEGS

IAN MCMILLAN
VS
ANDY MARTIN

FUEL

FUNNY

POET HERE

ON

THURSDAY

CONTENTS

FOREWORD 7

MESSAGES FROM A RUSSIAN HEATWAVE 8

ENGLISH/FRENCH MINI-DICTIONARYSCAPE 12

OVERHEARD PHONE CONVERSATION 13

THE BATTLE EXPLAINED OVER DINNER 14

THERE'S A NAKED GIRL IN MY TOILET 16

THE ADVENTURES OF THE MAN ON THE FIRE EXIT SIGN 17

HERBERTO THE CLOWN: A CALL FOR MEMORIES 18

SONG OF THE QUARRYMAN 20

SKY ALTERING TIME 22

ELVIS PRESLEY 24

THE PHOTOGRAPH ALBUM 26

WINTER NIGHTS IN THE CAFÉ WITH NO ROOF 28

RECIPE FOR A NEW MUSIC 29

THE LAXEY WHEEL 30

THOMAS'S FIRST WORDS 32

GOOD AGAINST BAD 34

A MINI FOLK SONG 34

HOW TO WRITE A TEEN MINI-NOVEL 35

HE TYPED BAT INSTEAD OF BOAT 36

THE TOWEL: A POINTLESS AND LINGUISTICALLY IRRITATING PLAY 38

SO HE WENT SEARCHING 40

NEWFOUNDLAND DAYS 44

A MINI VIDEO NASTY 46

CHESS COLUMN 47

WHERE'S MY BOCKS? 50

ENDLESS SHEDNESS 53

LANDSCRAPE 54

EACH DAY HE WALKED TO THE BRIDGE 55

MY BOOTS ARE PEOPLE 58

THE TROUSERS OF WISDOM 59

SCISSORSCAPE 60

WEDNESDAY MORNING 61

POETSCAPE 62

MY SOUP IS TOO HOT! 63

MILKSCAPE 64

CC IS MY WIFE IN A DREAM 65

SEESCAPE 66

THE DAY THE GREASE TIGER BECAME EXTINCT 68

CORNISH CLIFFS REVISITED 71

THE MYSTERY OF THE MAN WITH HIS OWN SEA 72

JOHNSCAPE 73

BRAVU MAESTRU! 74

THE MYSTERY OF THE MAN WHO COULDN'T RECALL THE WORD FOR SEA 75

WINNER 76

CLOSING MINE 79

THE SPIRIT OF CHRISTMAS 80

THREE RED LITTLE RIDING PIGS 82

A MINI-NOVEL 83

SHAKESPEARE RULES BRITAIN 85

HE MISSED HER TRAIN 86

DIGGING MY OWN GRAVE IN THE SCHOOL'S VEGETABLE GARDEN 87

THE MYSTERY OF THE SHANTYATTACKER 88

VANGOGHSCAPE 90

DEATHOFALANGUAGESCAPE 91

INTERROGATIONSCAPE 92

B SCAPE 93

BIRDTABLESCAPE 94

FERRETSCAPE 95

COFFEESCAPE 96

OKLAHOMA! 97

RONALD'S WORST DAY 98

DEFINITE INDEFINITE 99

ODDLY LYRICAL NEWS ITEM 100

THE PHILOSOPHER SPEAKS 101

MY LUCKY RUPEE! 102

MY COUSIN CAME FROM LIMERICK 103

I VISITED HER ON SUNDAY 104

THE BEARS WHO SAILED AWAY 106

AND IT'S GOODNIGHT FROM HIM 108

FOREWORD

There are hundreds of different ways of looking at the world, and this book provides another.

Ian McMillan, poet laureate of a parallel universe not necessarily near Barnsley, is that rarest of combinations, a bluff Yorkshireman and mystic. His eye for the beautiful and poetic in the moribund and everyday marks him out as one of our most cherished free thinkers, and here is further evidence, should such be needed, of his unique vision. If the goodness and greatness of the key individuals of our time are measured in radio appearances, and I very much think they should be, then how many other poets have appeared on BBC Radio 1, 2, 3, 4 and 5? It has been said that we judge societies on their treatment of animals, and whilst it's hard to imagine Ian knowingly inflicting suffering on a guinea pig, he symbolises a different but equally valid perspective: the celebration and treatment of our own language. If anyone has done more to engage the nation in wordplay and literary badinage, then I'm a merganser. Despite his good works around the nation's theatres, schools, broadcasting emporia and hearts though he remains steadfastly honest, unaffected, gleeful and wary of the meritricious. I am proud to call him a friend.

Andy Martin I don't know but I'm sure that if I did, I would love him as dearly as my own children. A superlative illustrator he has achieved the seemingly impossible, creating a vivid range of visual settings in which the golden wordage of the man we don't call Macca sits like a contented Buddha, but made out of letters.

There are hundreds of ways of looking at the world, but this is as good as any I can think of.

Mark Radcliffe
Manchester, England. Tuesday 11th April 2006. Late.

I was travelling in Russia,
and naively I thought it was going to be really cold
so I took jumpers and coats and scarves
and I got there, in the hottest weather, they'd ever had
in Russia for years.
People were dying.
And I felt like I was dying, as I lay there in hotels
that guide books told me not to stay in.
And my passport photo was really old
and I was followed all the way around Russia
by this young man, who used to be me.
And all that happened was,
as I kept sweating day and night,
I just, wanted to go home.

> > >

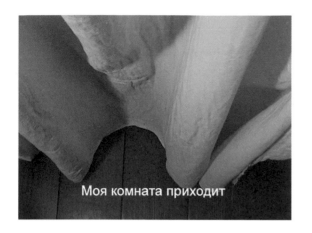

Моя комната приходит

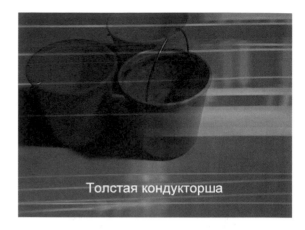

Толстая кондукторша

MY ROOM IS ENTERING A PERIOD OF TURBULENCE.
THERE, BY THE CURTAINS.

THIS IS MOSCOW FAST FOOD,
A MUSHROOM PIE
TASTING OF AIRPORTS.

FAT TRAIN CONDUCTOR IN A BLACK DRESS
SWINGING BETWEEN THE CARRIAGES
SELLING TICKETS,
TO THE PEOPLE WITH BUCKETS.

ONE SHEET, IS TOO MANY
ONE SHOPPING CHANNEL,
IS NOT ENOUGH.
ONE TEAR OF SWEAT,
DOWN MY BACK.

VADIM NEVER SPEAKS,
HE JUST DRIVES.
MAYBE HE'S COUNTING THE TREES.
I LOST COUNT,
FELL ASLEEP AT SEVEN HUNDRED THOUSAND.

Это московские закуски -

is too MANY

Одна простыня - слишком много.

прижимает к губам бутылку пива.

персоналом в аэропорту.

EVERY YOUNG PERSON IN RED SQUARE
HAS A BOTTLE OF BEER
CLAMPED TO HIS LIPS -
CLAMPED TO HER LIPS.

THE NIGHT PORTER
AT THE PERESLAVL HOTEL
COULD BE THE DEAD GRANDFATHER
OF ALL THE NIGHT PORTERS
IN THE WORLD.

THE FESTIVAL OF FACE SLAPPING -
TALKING, WHEN THE FLIES ARE OUT.

THAT YOUNG MAN, ON MY PASSPORT PHOTO
IS SNEERING AT THE AIRPORT STAFF.
HIS DARK HAIR IS AN INSULT TO THEM AND ME.

THIS FISH HAS MORE BONES THAN ME.
ANATOLY DOESN'T CARE.
HIS CELLAR IS COOL,
HIS VODKA HAS NO BONES AT ALL.

швейцаров в мире.

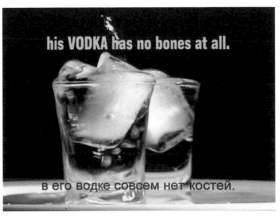

his VODKA has no bones at all.

в его водке совсем нет костей.

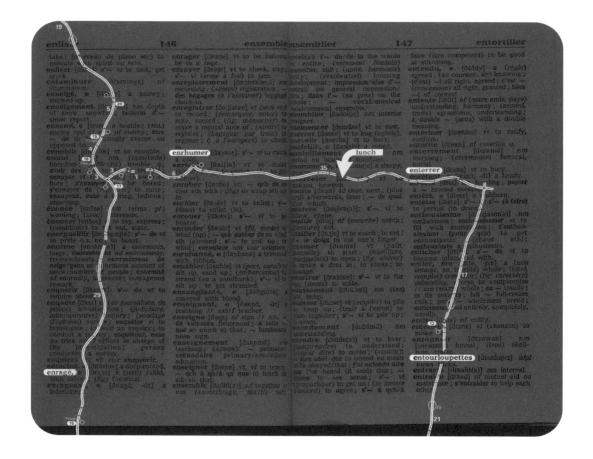

ENGLISH/FRENCH MINI-DICTIONARYSCAPE

Even this double-page spread is a week's walk, I'm **ENRAGER** to be climbing over these too tiny words, soon I will be **ENRHUMER**, this print is so chilly, perhaps I will be **ENTERRER** in here f'ever, or maybe I'll be found in decades by my grandchildren as they search for a word for a loving loveletter to their lovers in Lille. I'm here, by the **ENTOURLOUPETTES**. Close the book and I'm crushed by rage, by the common cold, by burial, by dirty tricks. I'm a pressed fleur.

OVERHEARD PHONE CONVERSATION

Hello?
I'm just ringing about the new name for cheese.
The name for the new cheese.
I thought Battleship. Do I win?
The prize, do I win it?
Battleship Cheese.
It sings, doesn't it?
Yes, it's my idea.

Hello? Sorry, went through a tunnel.
Yes, Battleship Cheese. Do I win?
I think of words all the time and Battleship just popped in.
Just sailed in, if you get me. Ha ha.
I just thought Battleship Cheese.

Hello? Do I win?
Oh, well, when will I know?
Oh. Well, when I win could you make sure the prize comes all at once?
Yes, all the deckchairs at once. For private reasons.
I'm on a train, so I can't tell you why I want all the deckchairs at once if I win.
I mean when I win.
Battleship Cheese.
It's a winner, isn't it?

THE BATTLE EXPLAINED OVER DINNER

SAY THIS SALT POT IS THE ENEMY TANK DIVISION.

SAY THIS PEPPERPOT IS THE ENEMY INFANTRY.

SAY THIS SPROUT IS A TREE.

SAY THIS LEEK IS A FIRE.

SAY THIS PIECE OF STRAY TURNIP IS A DESERTER ABOUT
TO BE SHOT.

SAY THIS SPOON IS A SHOUT FOR HELP FROM THE BARBED WIRE.

SAY THIS CUSTARD IS THE MAJOR'S HAT BADGE.

SAY THE STEAM FROM THIS TUREEN IS THE DREAM OF A YOUNG
CORPORAL WHO IS MISSING HIS FAMILY LIKE HECK.

SAY THIS PLATE IS THE MAP OF THE BATTLE AREA.

SAY THIS BROAD BEAN IS THE BUGLER ABOUT TO SOUND THE CHARGE.

SOME ON DAMN YOU, SAY THESE THINGS! THEN THE VIOLINS CAN
BEGIN THEIR WORK!

YOUR MOUTH IS HANGING OPEN LIKE A WARDROBE DOOR!

MINI FARCE
For the busy teen who's too concerned about real life issues
to visit the West End.

THERE'S A NAKED GIRL IN MY TOILET

Bedroom. Three doors. Open. Vicar. RAF Pilot. Girl. Run.
RAF Pilot. Trip. Rip. Girl's skirt falls off. RAF Pilot lends scarf.
Vicar. Hide. Toilet. Door. Open. Father. Banana skin.
Having treatment. Dermatitis. Rare form. RAF Pilot. Laughs.
Father's banana skin. Girl. Cries. Tears melt bra strap. Falls off.
Vicar. Runs. Sees banana skin. Laughs. Cruel. Father. Pocket.
Balaclava. Back to front. Banana skin hidden. Vicar. RAF Pilot.
Engaged. Father. Opaque balaclava. Window. Stagger. Smash.
AAAAAAA! Girl. Horror. Knickers fall off. Curtain. Applause.

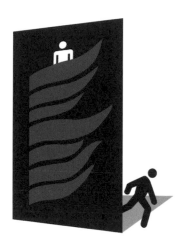

THE ADVENTURES OF THE MAN ON THE FIRE EXIT SIGN

There he is, legs cocked as usual, ready to run. Until we've all gone home, then the leg can subside and he can breathe again.

That's his brother on the toilet door.

Sometimes, for mischief, they do each other's jobs!

They were once conjoined.

:::

P U B L I C N O T I C E
--*-*-*-*-*-*-*-*-*-*-*

HERBERTO THE CLOWN
A Call For Memories

=========================

You may remember him because he was, in his way,
REVOLUTIONARY, especially in the late 1950's
in the SCOTTISH BORDERS.
He wore no makeup or OUTLANDISH clothes and had
no act to speak of. He would wander onto the
stage and sit on a stool. Occasionally he would
look up at the audience but mostly his eyes
were DOWNCAST.

After a few minutes he would get up and leave.

We can find no evidence of him after August 1961.

We know that, at each performance, at least one
person would LAUGH.

We would like to trace those people.

Did you attend a performance of Pipe's Circus
between 1957 and 1961, particularly in the towns
of Duns, Lauder, Peebles, Innerleithen and
Moffat? Do you have memories of HERBERTO THE CLOWN?
Do you have photographs of HERBERTO THE CLOWN?

We are in no way associated with the company seeking
information on Sputnik the Clown.

**

Thankyou.

**
:::

:::

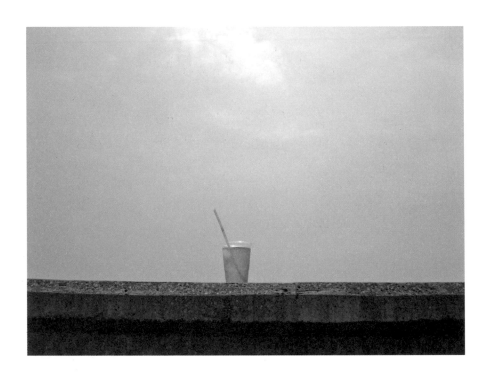

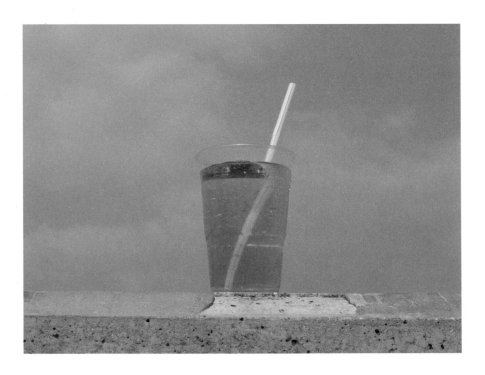

SONG OF THE QUARRYMAN

Sing me the *hard hat*,
Sing me the reflection of the sun and the snow in the glasses
Beneath the *hard hat.*

Sing me the *rumbling sorter*,
Sing me the distortion of the sun and the snow in the window
Of the cabin of the *rumbling sorter*
And in the glasses beneath the *hard hat.*

Sing me the *deep blue pools*,
Sing me the refraction of the sun and the snow in the surface
Of the somehow gorgeous *deep blue pools*
And in the window of the cabin of the *rumbling sorter*
And in the glasses beneath the *hard hat.*

He said
'it's an astonishing feeling
sun reflecting in the glasses beneath the hard hat
to think that we're uncovering something
sun reflecting in the glasses beneath the hard hat
millions of years old
sun reflecting in the glasses beneath the hard hat
and we're the first to see it...'
but I couldn't hear him
for the sound of the machine's song,
and the sun reflecting in the glasses beneath the hard hat.

Sing me the refraction
Sing me the distortion
Sing me the reflection

Sing me the *hard hat*
Sing me the *rumbling sorter*
Sing me the *deep blue pools*

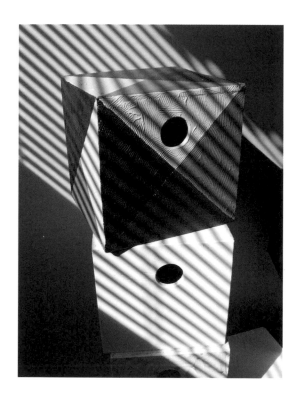

SKY ALTERING TIME

I think it's sky altering time. And this is the horizon shaping place. And I'm walking in a Rolls-Royce world. Space: plenty here.

There are straight lines here. And this is an understatement; the straight lines are dancing their straight line dance. And that was an understatement. The straight lines are living in their own city, the city of straight lines. And that might be a statement, but there can be no overstatement when it comes to straight lines. Because this is a Rolls-Royce world. They make shapes here. Plenty.

Actually, I know it's sky altering time, because the sky has altered since I got here and signed in at the gatehouse. It's a scape, I guess: a Rolls-RoyceScape, altering the sky like any boom does, any building boom, any construction dance, any straight line festival. And this is certainly a building boom. Or a building getting ready for a boom. Or a building to test a boom. A building boom. A building. Boom.

A boom building.

Everyone here is dedicated to altering the sky, to building scapes, to shaping the places we live and work. All I do is make marks on paper, sound alterations in the air. Airscapes, sentence-scapes. This feels permanent.

Although of course it isn't, and that's part of the beauty. But only part of the beauty.

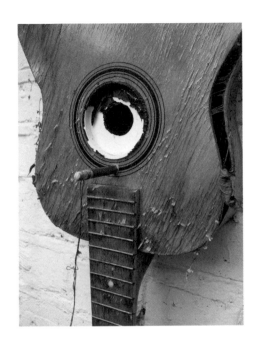

ELVIS PRESLEY came to our school.

He came in the door and Miss McCorquodale said 'MY GOD'. **ELVIS PRESLEY** walked through the door kinda funny. He seemed to hang around in the doorway for a long time and then he burst in. Joey Kowalski said he got stuck in the doorway but Joey Kowalski likes Creedence Clearwater Revival.

ELVIS PRESLEY went over to the teacher's desk. He was dressed in a black leather suit and he was a big guy like my Uncle Virgil. He wasn't singing like he does in the films of his I've seen on TV. Miss McCorquodale looked sick. **ELVIS PRESLEY** said to her 'Hello Mrs Toomer, I've come to present the cup.' Joey Kowalski said to me that Miss McCorquodale looked like she was going to throw up because she was looking at **ELVIS PRESLEY'S** big fat mouth. I told him to zip his lips or he'd have the fattest mouth in Concord.

ELVIS PRESLEY reached into his pocket and pulled out a little silver cup. 'Where's the kid, Mrs Toomer?' said a thin man from the doorway. He must have been **ELVIS PRESLEY'S** friend. Miss McCorquodale was trembling. She looked just like she was going to faint. **ELVIS PRESLEY** waved the cup above his head. 'Who wants the goddamn cup?' he said. 'Where's the kid, Mrs Toomer?' said the thin man again from the doorway.

At last Miss McCorquodale spoke. Her voice was like a gerbil squeaking. 'What kid?' she said. That's all she said. The thin man looked at a sheet of paper. 'Ramon Rodriguez of Brooklyn. He's won a cup in the 1975 Draw a Picture of Elvis competition.' Miss McCorquodale began to whine. High pitched. It was terrible. Lucy Billington got up and said 'This isn't Brooklyn. This is Concord, New Hampshire. Brooklyn is in New York City.'

Well Lucy Billington was just showing off. I could have told him that. There are five boroughs in New York City; Queens, Manhattan, Brooklyn, the Bronx. And one other. I can't remember it but I know there are five.

The thin man shouted out into the corridor, 'This ain't the right school. The kid says Brooklyn's in New York City.' There was another voice in the corridor saying things I couldn't catch and then the thin man shouted 'No! Fucken New York City!' The thin man came into the room and said to **ELVIS PRESLEY** 'Put the fucken cup away.' The thin man led **ELVIS PRESLEY** away and I covered my eyes up because I didn't want to see him get stuck in the doorway again.

But Joey Kowalski laughed so I guess he must have done.

Dwight Folsten, Concord, New Hampshire

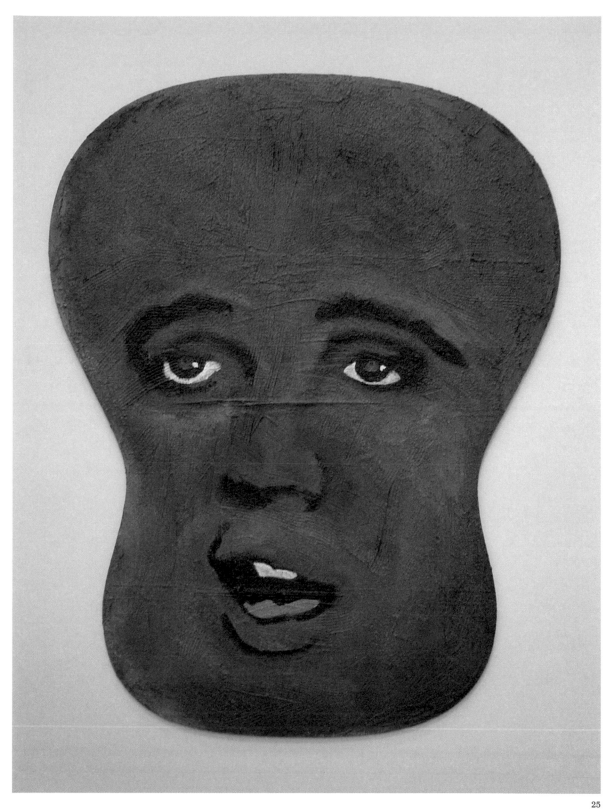

THE PHOTOGRAPH
ALBUM

This is a good one.
This is a good one.
You'll like that one.
I don't know who that is.
He looks like your dad.
That can't be her.
He married that woman.
That's a poor exposure.
Where is that, exactly?

There's a couple missing on this page.
I used to love that tree. This is a nice one.
Turn the page quick, I don't want to see her.
You'll like that one. I don't know who that is.
I don't know where that is. That cap never fitted him.
She always had that scarf. Where is that, exactly?
Too much sun. That's a nice one.
That's lovely. That wall seemed so high.
He's dead.

WINTER NIGHTS IN THE CAFÉ WITH NO ROOF

The chic crowd colonised us for that whole Winter.
They dressed up warmly, brought their Sartre and
their waistcoats and their endlessly boring
harmonica music.

Sometimes I wish I lived in a town where the chic
crowd didn't play harmonicas.

I blame the war, of course. But everybody blames
the war. 'You can't have a pie without eels' as the
saying goes.

But nobody told us when the war started, and nobody
told us when the war ended. And at times, there was
no indication that we were in a war.

You can't have a pie without eels, eh?
Tell that to the rugby referees!

RECIPE FOR A NEW MUSIC

Take the turtles.
Place them on the keys of the piano.
Carefully, now.
Carefully.
Wait.
Wait for years.
Wait for decades.
Turtles live a very long time.

Wait, and the music will come.

Is that it?
Is that the new music?
Perhaps.

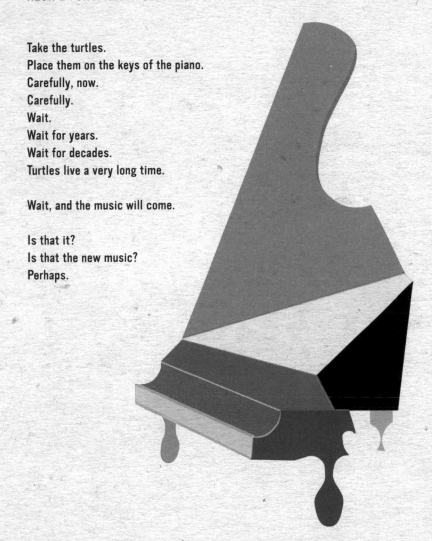

The Laxey Wheel, Endlessly Spinning

THROUGH MY DREAMS
AND ELBOWING ASIDE
MY FAVOURITE SOUP.

Adhesive
Whisk
Fish
Cheese
Yes
Brocolli

Thomas's first words, 10/11/05

SPANISH
PLUMS
VARIETY: SANTA ROSA
CLASS I 500g

GRUNDIG

3½%
FREE OF TAX
SOCIETY

STATE
BUILDING SOCIETY

33

"GOOD AGAINST BAD" by John Good

Two brothers. Simon. Lorenzo.
Simon is good. Lorenzo bad.
Lorenzo steals money. Simon says Give it back.
Lorenzo says No.
Simon tells police. Police take Lorenzo.
Lorenzo in prison. Not good to be bad, says Simon.
Pardon? says Lorenzo. NOT GOOD TO BE BAD. says Simon.
Now I understand says Lorenzo.

A MINI FOLK SONG

For the teen who'd like to spearhead the folk revival
but who's too busy making party to talk to shepherds.

Morning. May. Maiden. Soldier. Hay. Chorus.
Nine months. Child. Soldier gone.
Maiden at home. Chorus.
Soldier comes back. Chorus.
Soldier goes. Chorus.
Soldier comes back. Chorus.
Soldier. Braces. Caught in door.
Chorus.

HOW TO WRITE A TEEN MINI-NOVEL

For the busy writer who hasn't
got time to get up in
the morning.
Bedroom. Six pm. Curtains drawn.
Author. Groans.
Reaches for portable typewriter.
Reaches for paperback.
Reads summaries of other books
on back page.
Ponders a moment.
Copies out plots.
Mother. Shouts up stairs.
Postman. Knocks on door.
Large cheque for author.
Author buys mother fur coat.
All happy.
Editor. Suicidal.

HE TYPED BAT INSTEAD OF BOAT

She was leaving on the next bat out of Liverpool.
'All aboard!' they shouted as the bat's wings
shifted in the wind.
The huddled masses, hoping for a new life
in a new land, carrying their few possessions
up to the bat's back and trying to avoid it's
blank stare, it's frightening ears.

 She was hoping for a life in some shiny town and
 she wanted to think that a journey by bat across
 the harsh Atlantic would would one day be a
 memory she could laugh about with her Grandchildren
 who would be talking like Americans.

 But she could not avoid the bat's blank eyes.

PLATE WARMERS · WASI

Philip

THE TOWEL: A POINTLESS AND LINGUISTICALLY IRRITATING PLAY

HE: He was the worst wrestler I've ever seen, to be fair.

SHE: Was he, you know, as bad as Smuke?

HE: Much worse, to be fair. No mat skills.

SHE: Was he, you know, worse than The Blacksmith Twins sort of thing?

HE: He was, to be fair. Never won a match if you get me.

SHE: Was he, you know, worse than The Pole?

HE: He was, to be fair. Worse than old Slvovovovovitc.

SHE: His name, you know, kind of didn't help sort of thing.

HE: To be fair was a sort of disaster sort of thing.

SHE: A wrestler called The Towel you know sort of thing it's a bad you know name sort of thing.

HE: To be fair The Towel is a bad name. And no mat skills, to be fair.

YES WE ARE ALL ASKING; WILL THE BUS NEVER COME?

STRIKE!

FOR THE CITY AUDITORIUM

Monday Evening, May 30th

TO CHEER

Your Favourite

IN THE CATCH AS CATCH CAN

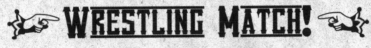 **WRESTLING MATCH!**

BETWEEN THE FAMOUS

 ## SMUKE

AND

THE TOWEL

EXTRA!

WILLIAM KERR

The Celebrated Bag Puncher

WILL APPEAR BETWEEN THE BOUTS.

✳ POPULAR PRICES ✳

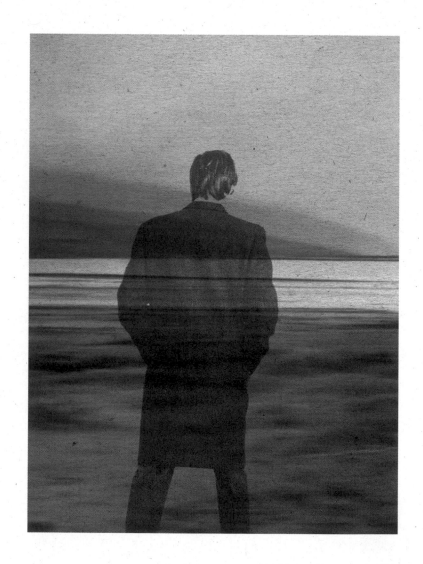

SO HE WENT SEARCHING:
A STORY TRANSLATED FROM THE OLD LANGUAGE

So he went searching, and he took no special clothes in the mist, because he never had any. No special clothes for the mist. He had the special fog clothes, but he left them in the green bag. Because it was mist, not fog. He left the drizzle clothes, and the miasma clothes.

So he went searching, as the dawn split, and he carried on, as the afternoon grumbled and the evening squeaked like a door.

So he went searching. He would search for forty five minutes, then he would hold up a piece of wood with a number on it and he would search for the same number of minutes as the number on the piece of wood and he would search in a small space, the number of yards he searched being the same as the number on the piece of wood. Then he would stop searching for fifteen minutes, and in that fifteen minutes he would eat a lukewarm clod of earth. Then he would search again for forty five minutes, then he would hold up the piece of wood, and search again for the number of minutes and the number of yards. He searched like this for years and years, always in the mist, and he never had the mist clothes, always alone and he never had the mist clothes.

So he went searching, and over the years each year had the same pattern, the same turning, the same soft spinning like the spinning of his apple when he dropped it from his bag to the floor. Always the mist, of course. Always the mist. Each year would begin in the heat of August, hot summer mist like the steam from a kettle, the searching done with optimism, with belief. Each year would collapse into a dirty autumn, an autumn that needed a bath, mist clinging like a cold vest that he put on too quickly from the washing line, still damp, still holding tight, still searching but this time the optimism smaller, like this: optimism. Each year would freeze into a solid winter, when the fields he walked over were hard as iron, and the water he drank was like a stone, and the mist cut like a breadknife, and the searching seemed pointless as he would arrive somewhere to search only to be told that the search had been called off for that day. Each year would lift into Spring, when artificial light was no longer needed, and the mist was somehow brighter, lighter, like the mist from a perfume spray and the optimism was there again, this time it was more than optimism, it was **(Translator's note: at this point the writer uses a word that cannot be translated from the language. The word** thnebbo **means something like 'hopeless optimism' or 'unlikely optimism' or 'optimism that is totally unfounded and yet very strongly held')**. Each year the search would stop, for others, and they would sit in their homes waiting for the time for the search to begin again but he carried on searching, in the mist.

So he went searching, and sometimes, in the mist, he thought he'd found what he was searching for. They would loom through the moist lost mist like ancient temples or childrens' drawings of ancient temples or dreams of ancient temples. The posts. The crossbar. Sometimes (and this almost made him weep with joy) nets pulled into holes or pieces of misty string that were bones of nets, fossils of nets. He would tramp to the middle of the field and gaze to his left: posts, crossbar. He would gaze to his right: posts, crossbar. He was in the middle of a Posthenge, on a spot the mystics

called The Centre Spot. He would sink to his knees and laugh. Then he would look again, and they wouldn't be quite right. They wouldn't be perfect. They wouldn't be what he was searching for.

So he went searching, in the mist, and often when he'd had a day of disappointment, thinking he'd found what he was searching for and then realising he hadn't, we would have vivid and frightening dreams where his wife and his children and his brothers and sisters and his old mother who'd been dead twenty years and his old dad who still lived on in a place called The Home rather than Home would come to him and they would sing, like a choir, or like people who wanted to be in a choir but couldn't quite sing in tune or keep a rhythm but who made a loud and powerful noise anyway. And the song they sang was always more or less the same. A few words would be different each time but not many. Not many at all. The words would always be something like: **Come back/ Just come back/ Just come baaaaa-aaack/ and we'll let you make posts in the garden/ you can stretch nets over the posts in the garden/ Come back/ Just come back/ Just come baaaaaaaack/** (That was the chorus: join in if you like, wherever you're reading this) **Come back from your searching/ we are your family/ you are our husband, or father, our son/ Come back/ Just come back/ Just come baaaaaaaaaaack/ Real life isn't what you are doing/ real life is going to the shops and cleaning your shoes/ and shaving and looking both ways when you cross the road/ real life isn't what you are doing/ Come back/ Just come back/ Just come baaaaaaaaaaaaa-aaaaaack!** And as the chorus got louder he would force himself out of sleep and would lay there sweating, often in the middle of a field in the mist with the Moon looking down. And he would stand up and walk, past the posts that he knew were not the ones he was searching for.

So he went searching.

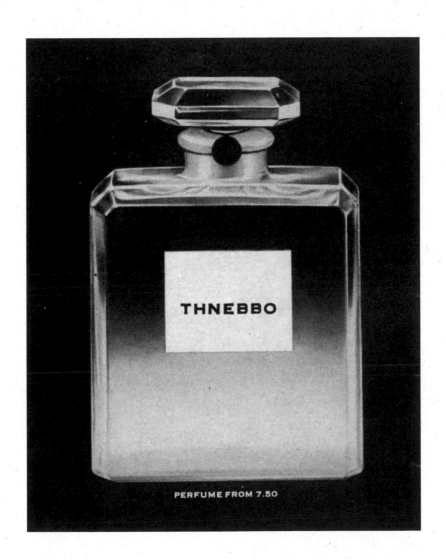

NEWFOUNDLAND DAYS

The immigration man doesn't like the look of me. In his office. He looks like Peter Glaze. 'What it the purpose of your visit?' He asks me in the voice of a toy robot. 'To write a piece about how welcoming St. John's is.' I reply. Then we'd better let you go, buddy.

Eggs Benedict. Alone in this dining room. I think the Eggs may be speaking but I don't talk Newf.

Suddenly in from the cold to The Rose and Thistle my glasses steam up. A man (let's be frank; a shape) hands me a tissue. Same thing happened to me last week, sir.

A man approaches asking me for change. But surely we all want change, I say to him. Then I see the icebergs in his eyes, and I know what he means.

Look at me, eating quail. I think the quail may be speaking but I don't talk Newf.

In the drizzle I feel like I'm in the Rose and Thistle again but where is the man with the tissue when you want him?

Early morning on the street a man in womens' slippers comes out, stretches, puts something in the dustbin, and goes back into the house and if this was a film this would be significant.

The singer-songwriter is singing songs he's written and I'm sipping Canadian Beer. Hey, I look like a Canadian. Not with your glasses steamed up like that. I'm watching you, buddy. Ah, hello, Mr. Glaze.

Or the shape of Mr. Glaze. It's all icebergs to me.

A MINI VIDEO NASTY

Condensed for the busy teen who
doesn't have time to sit and watch.

Girl. Hotel. Shower. Soap. Singing. Outside. Mad Leonard.
Village idiot. Slavering. Shower. Girl. Singing. Mad Leonard.
Shower curtain. Rip. Girl. Scream. Axe. Limbs. Blood.
Mad Leonard. Flask. Blood in flask. Horror. Later. Home.
Dingy. Mad Leonard. Bedroom. Corpses. Limbs. Head. Feet.
Teeth. Mad Leonard drinking from flask. Disgust. Next Day.
Police. Shower. Curtain. Evidence. Mad Leonard's wig attached.
Home. Dingy. Mad Leonard. Chewing leg. Police burst in.
Fight. Mad Leonard severs six heads, four legs, other parts.
Mad Leonard overpowered. Shot. Policeman. Gun. All sit.
Police eating. Chewing Mad Leonard. Joke ending.

'There are some bishops on the board! They think it's all over... it is now!' Yes, I can see it happening, I really can: televised chess elbows football aside and the black and white squares take over from the green and gorgeous grass as the stage for the theatre of dreams.

This is fantasy, this is speculative fiction, but tape this column and play it again in ten years and see how much came true. Plenty, I bet.

Ten thirty on a Saturday night. In millions of front rooms the family settle down for *Match of the Day*, highlights and comment on all the Premier League Chess Clashes from the mighty Stamford Bridge Check Lounge to plucky newcomers Wigan No-Need-To-Be-Athletic. A slo-mo pawn to Queen's Knight three. An action replay of that astonishing moment when the King walked straight into trouble, not seeing the Castle sneaking up on him from behind.

In the studio, the pundits shake their heads. The same pundits, of course, because in these slim times for the BBC one pundit fits all. Gary Lineker refers to the new castle they had to bring on for AsPawn Villa as a 'rookie' because one pun fits all too, and in the olden days of football we wouldn't have got it but now in the new days of chess we all do. Because chess is the new football, the new rock and roll. Black and White is the new black as Trinny said to Susannah the other day. 'It's the defence' moans Alan Hansen, 'it's always the defence' and he tracks how a white knight charged through a gaggle of black pawns like they were standing still. Which, in truth, they were.

Because they're not people.

And that was part of the problem when chess began to be televised in 2005; to be frank, nothing much happened. It was like watching fretwork without the visceral excitement. It made sitting on a cliff gazing at a sunset feel like an hour on the biggest roller-coaster in the world. We had a lot of close-ups of brows being furrowed, and the camera would zoom in on a hand reaching for a pawn and then retreating. Viewing figures weren't good. Not good at all.

So, as with the football and the cricket and the rugby union and the rugby league, Sky came to the rescue in its own Skyish way.

They renamed it *Battleboard*. They set up a league structure, from a Premier to a Conference, so that in theory the Boys' Club from Bacup could one day take on ManChessTer United. They employed known faces like Carol Vorderman and Natasha Kaplinsky, one in black and one in white and, in a masterstroke, they got unemployed actors to recreate the moves on a giant board in a city centre in front of an excitable crowd worked up by days of café-style 24-hour drinking.

So, as a hand moved a knight on a big screen, a lad who once carried a spear in *Richard III* on a tour of the East Midlands and had a walk-on part in a soup advert zigzagged across the board like he was made for the part of the Black Knight. Remember, you heard it here first. Chess is the new sex. Time to get ready for the Friday night game: now where's my Bishop-shaped airhorn?

Aft
or
fic
'S

LOOK 10

FREE 1ST EDIT
*'GREENHOUSES FOR
PLEASURE WITH PROFIT'*

INVEST *NOW!*
2½ ACRES

Your Poem
(HERE)
written down
like
THIS

WHERE'S MY BOCKS?

That's what he always sang, in the frightening area near the lake. He became a bit of a tourist attraction, but only for a short time one damp Summer.

His voice was thin and high. Coach parties would take a detour from the Palace and the Memorial and people would get off the bus and look at him and listen.

You could buy t-shirts that said:

I DON'T KNOW WHERE YOUR BOCKS IS AND I DON'T CARE WHERE YOURE BOCKS IS BECAUSE I'VE GOT TROUBLES OF MY OWN but the vendor was left with many unsold ones.

ENDLESS SHEDNESS

LIFT LID OF SHED PEER INTO
ENDLESS SHEDNESS BELOW

A KIND OF BLUE SKY SHEDNESS
A KIND OF ENDLESS SHEDNESS
LIKE THE CORNERS YOU FIND IN SHEDS

LIKE YOUR SHED HAS MORE CORNERS
THAN YOU THOUGHT POSSIBLE

ENDLESS SHEDNESS
YOU ALWAYS FIND THINGS IN YOUR SHED
THAT YOU NEVER PUT THERE
THAT YOUR PARENTS NEVER PUT THERE
THAT YOUR CHILDREN NEVER PUT THERE
ENDLESS SHEDNESS

TRY THIS NOW
WITH YOUR OWN SHED
AND YOU WILL FIND THE
(ENDLESS SHEDNESS)
THINGS THAT WERE NEVER PUT THERE

ENDLESS SHEDNESS
ENDLESS SHED
E ESS S ESS
E E E E
LESS SHED
LESS HED
ENDLESS SHED
ENDLESS SHED

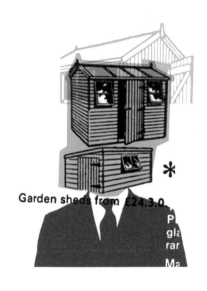

Garden sheds from £24.3.0

*

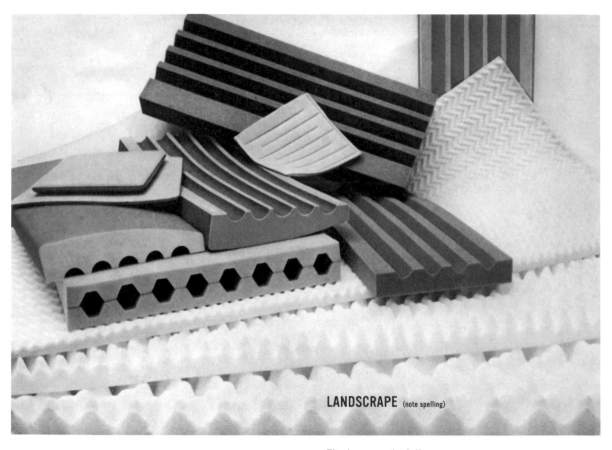

LANDSCRAPE (note spelling)

The lines on the hills.
The marks on the rivers.
The scratches on the fields.
No contour untouched.

EACH DAY HE WALKED TO THE BRIDGE

Each day that Winter he walked to the bridge;
he watched his breath clouding ahead of him as
he took his short strides down the side street to
where the bridge waited.

If a bridge can wait.

Each day that Winter he slowed his short strides
as he got closer to the bridge, his breath
clouding, as though he didn't want to get to the
bridge, or as though he wanted to savour the
moment of getting to the bridge.

If a moment can be savoured.

Each day that Winter he stood on the bridge.
He saw his breath. He watched the water.
A witness might have seen him cry. A witness
might have heard him sobbing. A witness might
have remembered this for years.

If a witness had been there.

Ah, these cities, they're all the same in Winter.
The canal, the bridge, the sun low in the sky.
The shadows as long as your memory.
Definite, indefinite.

Each day that Winter he stood for a time
looking at the water. Each day this is all that
happened. There were no witnesses. Nobody
saw, nobody heard. Except you, except now.

If you can hear.

IF A BRIDGE CAN WAIT..

10

12

9

IF A MOMENT CAN BE SAVOURED. **11**

14 IF A WITNESS HAD BEEN THERE.

16 IF YOU CAN HEAR.

13

15

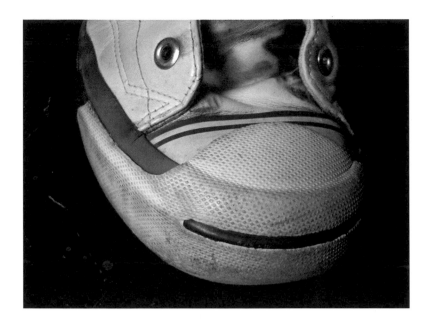

MY BOOTS ARE PEOPLE

How about that? Eh?

As though this is the opening line of a conversation in a crowded pub.
How about that strange fact, eh?

My boots are people.

Now you have everyone's attention. The music has stopped and the talk has
stopped mid-sentence.

Yes, my boots are people. They really are people.

This is not working. The conversations are starting again. Why does this happen?
I bring the firework to the party, and then when I let the firework off, everyone is
disappointed. Perhaps I should elaborate on the boots.

One of them is a Vicar from Ramsgate and the other one is a Chef who lost his job
and now sits all day in an abandoned bus in a scrapyard.

Too late. The music had started again, the talk is growing. Try the song:

Are you ready boots? Start walking...

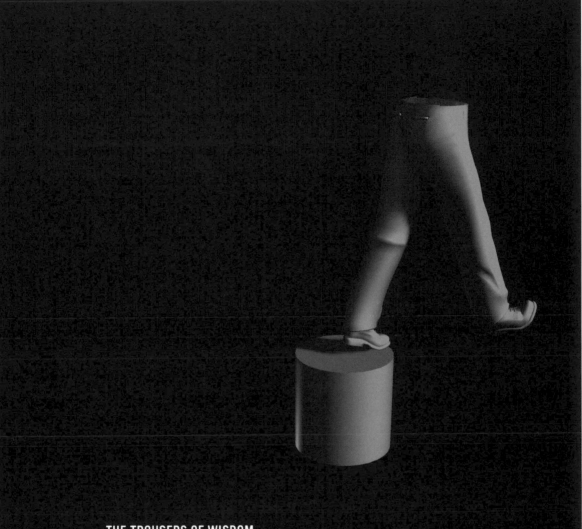

THE TROUSERS OF WISDOM

Uncle Keith has lost The Trousers of Wisdom. He looks into the fridge. He listens to the inside of a shoebox. He counts the number of turnips in the shop. He sings down the phone to the speaking clock.

And without The Trousers of Wisdom, his legs grow increasingly cold.

Cold as this: BRRRRRRRRRRRRRRRRRRRRRRRRRRRRRRRR

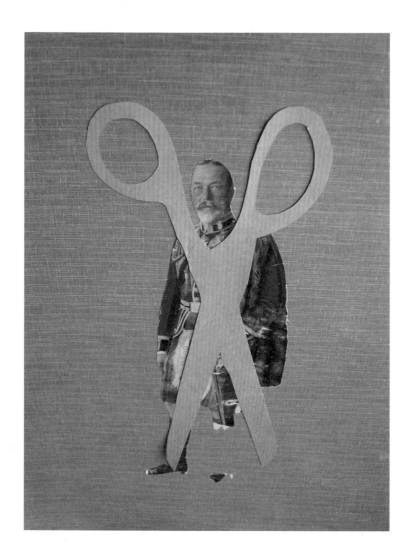

SCISSORSCAPE

It would be difficult if not impossible to walk on this scissorscape without the sturdy boots, even though in reality this is just a table top scattered with scissors. From above, maybe you could discern a pattern, but I couldn't, even with my boots on. Nail scissors. Paper scissors. The zen scissors with only one blade. Bacon scissors. Big blue plastic novelty scissors the size of a lamb. Isle of Wight bread scissors from Godshill. And the bastard sons: shears, pinking shears. I'll walk across the table in my boots. Watch me walk. Sharp walker.

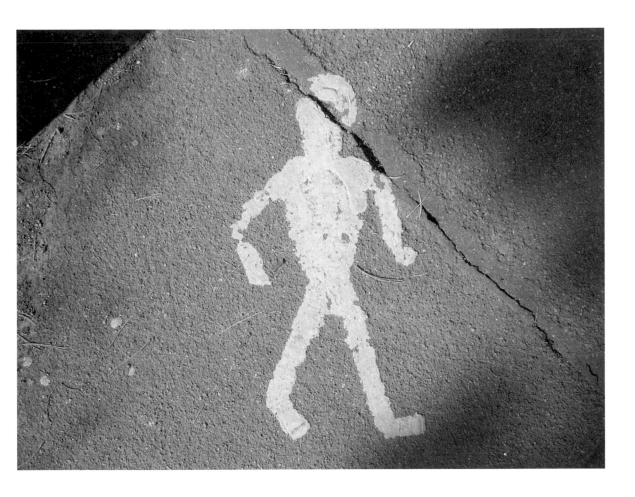

WEDNESDAY MORNING

The moment the shell cracked I knew it was really
the crack of Dawn.
I avoided the cracks in the pavement and I noticed
a crack in the cup I was drinking my tea from.
I went to Ladbrokes and put all my money and all
my shirts on a horse called The Crack running in
the 2.30 at Ludlow.

You can imagine that the hours up until 2.30 were
endless. I filled them with the violin.

POETSCAPE

Everyone in this jostling crowd is holding up a slim volume, printed in the brightest green. The ones with the longest arms are getting the best reviews.

It's okay, the skip isn't far behind, carried on the MIGHTY skip lorry.

MY SOUP IS TOO HOT!

Good, that's got your attention. I thought it would. People always glance at a story with soup in the title. Anyway, that's by the way. The fact is that I am Sir Arthur Quiller Couch, and I am trapped in this paragraph. Been here since 1923. Damned lonely, I can tell you. There have been tears a few times over the decades. Anyhow, I haven't much time. They'll be here soon. You can help me to escape. Just grab the cup. Grab it. Go on, grab the cup. This cup. Here, this cup. Come on, just grab it.

MILKSCAPE

The ingredients are somewhere in my pocket.
In my pale, pale pocket.
I do not want to touch the keys.
I do not want to touch the shreds of tissue.
I do not want to touch the dust.
Now I have found the milk in its bottle and it spills over my legs, on the floor.
I think I'll call it my floor, as I'm standing on it.
My floor.
Hello my floor.

CC IS MY WIFE IN A DREAM

Her voice hangs over the dream like a drying shirt hangs on
the radiator's goodness. In the dream we have been married
for many years, but there is a vague anxiety. The anxiety is
to do, somehow, with the hairs on my back. I know that we
have children and that one of them is called Melody. The
hairs on my back have dominated our long marriage like an
ungiven kick can dominate the life of a dog.

She wants me to remove the hairs, I think. But she wants
me to do it artistically. That's it with dreams: the anxiety is
always vague.

Even after the waking up in the cold room.

SEESCAPE

She put her contact lenses in.
Then her glasses over the contact lenses.
Then a magnifying glass.
Then a telescope.
Then a milk bottle.
Then a jam jar.
Then a diamond.
Then a shard of glass from HG Wells's greenhouse.

Then a leaf.
This spoiled the effect.

THE DAY THE GREASE TIGER BECAME EXTINCT

Mrs Jones, for one, was deeply distressed. 'It was as though a light had gone out in my life' she told me, collecting the milk from the step.

I asked her to elaborate. 'Well, you know when there's a power cut and you stumble about in the dark before you find the torch; that's how it felt.' She put the milk in the fridge. I asked her if she could elaborate further. 'Well, you know how when you find the torch and it doesn't work and it's still dark and you can't see a thing and you find the matches but you can't get them to light; that's how it felt.' She took the shovel from the fridge to accommodate the milk. I asked her if she could elaborate further. 'Well, it's like when you fall down in the room because it's so dark and your face is down in the carpet and you turn over and a hat falls from the hatstand and covers your entire head; that's how it felt.' She took the wheelbarrow from the fridge to accommodate the milk. I asked her why she kept a shovel and a wheelbarrow in the fridge.

'Perhaps I can explain that best with a song' she said, reaching into the fridge for the oboe.

CORNISH CLIFFS REVISITED

Those moments, tasted once and never done
Of long surf breaking in the mid-day sun
A far-off Henry chucks his bottle just for fun;

Young people mob and circle in plain sight
Long into the gorgeous Cornish summer night
Wrecked on the shore of dawn's hungover light;

These stags and hens take Cornwall for a ride
In Daddy's 4X4 with fifteen squeezed inside;
They roll in, roll out; like weather, like the tide.

Open their Vuitton wallets and the money spills,
And there's the paradox: you pay for thrills
And paying's what delights these Cornish tills.

Their cash is fine; it's just the way they roar
And screech and bray and soil their silky drawers
And fight their late-night popped up teenage wars.

And in the shadowless, unclouded glare
John Betjeman's ghost just sits, and stares
As late night mayhem rips the air;

He wants to write about this chaotic age
Where booze and yells have taken centre stage
But look: Tristan's spewed on the old bloke's pristine page!

Toffs have always colonised, it's true
Painted maps bright red that once were fresh and blue
But, on the whole, I like an unspoiled view

And I've asked John Betjeman, and he does too!

THE MYSTERY OF THE MAN
WITH HIS OWN SEA

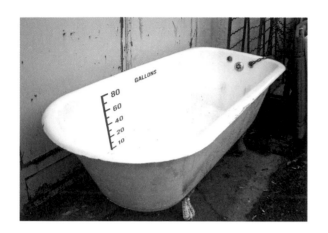

He wonders why he wakes with his pockets
full of seaweed. Years ago, he went to the
sea, once. It was a bright day, he remembers.
The bus lurched. He felt sick.

The sea seemed a long way away. A line at
the bottom end of the sky.

He stood looking. He held his mother's hand.
'Twice Round the Bay!' his mother shouted to
the distant waves and 'All Aboard the Lovely
Nancy!'

And that was as close as they got. And ever
since, once every few years ago (as he altered
from a boy to a man, hair scribbling his arms
and chest, his voice tumbling downstairs to
the cellar) he wakes with his pocket full of
seaweed, the taste of salt vivid in his mouth,
his eyes gritty with sand.

It frightens him. He stands looking at his face
in the bathroom mirror and the bathroom
lurches like a boat. Man with his own sea,
that's who he is. Man with his own sea.

Pockets full. Bathroom mirror slipping as the
big wave hits. He cleans his teeth of ocean.
Empties his pyjama pockets, running the taps
as the sea gurgles away.

But, on the train on the way to work, somehow
he feels that people know. They know.
They know he is the man with his own sea.
Man with his own sea.

He sneezes in the quiet carriage.
A mackerel lands on the table, wriggling,
gasping for breath.

And accusing him with its terrible eyes.

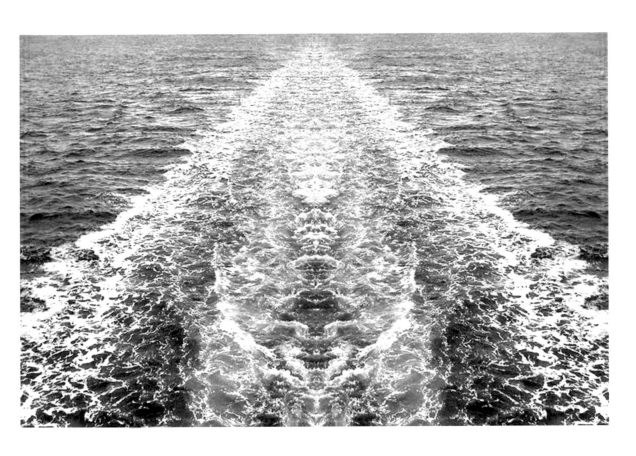

JOHNSCAPE

All the people on this ferry look like my brother. The clouds have my
brother's hair. The sun, peeping, has his face. The fish, swimming behind
the ferry, are Johnfish. The gulls screech: Johngulls. All the people on
this deck look like my brother.
He looks like me. I look like my brother.

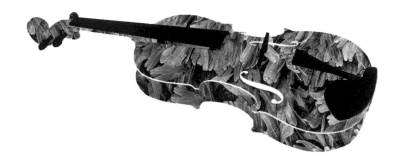

BRAVU MAESTRU!

Ah, bravu! Bravissimu!
Those seaweed violins!
The way they scrape!
Bravu!
The bladder wrack cracks incalculably
at the arse end
of each cracking movement,
Maestru!

And yet the stage hands clear the stage
with sad expressions.
They wear gloves
to keep the sea from their hands.
The maestru stands
at the side of the stage.
Are those tears, or is it the sea?

Ah, who cares? Bravu, maestru!

THE MYSTERY OF THE MAN WHO COULDN'T RECALL THE WORD FOR SEA

His lips move, making the contortions, and indeed his lips and tongue are shaping and shaping the space in the air where the word Sea ought to be. So long at sea, year after year. And the word gone.

They showed him pictures of the sea. What's that? they said. TABLE he said. Well, it was flat.

CHICKEN IN FLIGHT he said. Well, it was choppy and a little flappy.

THE COLOUR OF MY HAT he said. But his hat was red. NO, THE HAT THAT WAS LOST he said. THAT HAT WAS BLUE.

He knows what the Sea is, the clever scientists said. He just doesn't know the word.

They showed him a photograph of Seaweed. DOGWEED he said. They showed him a picture of a seashell. HOOVERSHELL he said.

They asked him to say the Alphabet under test conditions that involved lights and electrodes. A B D E F he said and they stopped him there and turned the lights off. His brow glowed in the dying glow.

They showed him a photograph of the sea. FRIDGE he said.

Then, in a stroke of genius, they showed him a film of the sea, and the soundtrack was a jaunty accordion and he said THAT IS THE SOUND OF THE WORD I CAN'T SAY.

And they brought in a man with a jaunty accordion. And he played for the man who couldn't say sea. And they let the man who couldn't say sea touch the keys and play a little.

And I don't know if music is more important than language, do you?

And that's a question we should think about tonight.

We should search for words to the sound of a jaunty accordion.

Until we say the word SEA.

WINNER

I always like to listen in to conversations on trains and buses; it's my job you see, as a writer, to keep my ear to the ground (or my ear three inches away from the couple who are leaning into each other and whispering sweet nothings on the seat in front of me on the train which I can achieve by pretending to retrieve a dropped pencil) to make sure that when I write dialogue it's of the realistic kind and not of the 'Charles, you've got a gun in your left hand which is rather odd for an accountant in his late forties with a pronounced limp' variety. That's what I tell myself, anyway. Really, I'm just nosey. A noseypoke, as my mother used to say.

The other thing I like to do on trains is glance at the open laptops of the besuited business types tip-tapping away next to me. Sometimes they're just playing patience. Sometimes they're reading through impenetrable reports on something I'm completely clueless about, like triple glazing on microwave oven doors. Sometimes, though, they're sending emails, and that's when it gets really interesting.

I shouldn't. I know I shouldn't. I'm a noseypoke. The other day, though, I couldn't have missed something on a bloke's laptop even if I'd wanted to. He was sending emails as the train rolled through the flatlands south of Retford and he had a template for them. What that meant, of course, was that he had his company logo at the top of each email, and his address and then at the end (and I'm not making this up and I wish I was) there was his name in big letters, and next to that, in even bigger letters the word WINNER. His name wasn't John Smith but if it was it would have said John Smith: WINNER. Poor old John Smith, in his suit and tie and with his laptop open in front of him, reminding everyone

he communicated with that he was a WINNER. I'm going to stop shouting now, by the way: it's giving me a HEADACHE.

I sat on the train and I thought about winning. Once, years ago, when I'd not been freelance very long, I decided that I wanted to make my life even more financially precarious. I was young and daft and anyway I've always thought that financial security was dull. I decided (to myself, I never told anybody else about it) that I would make my living by winning competitions. I'd read an article somewhere about somebody who did just that, with cash from cash prizes and food from food prizes and houses from house prizes and holidays from holiday prizes and I thought: that's for me. I sent off for a magazine that claimed to list hundreds of competitions and I entered them all. The magazine advised you to send bright and colourful postcards because somehow they came out of the hat more quickly so I bought a load of cards of Barnsley Town Hall and entered three or four pages worth of competitions. Then I sat back and waited. I've never really been a get-rich-quick chap but I figured this could be my time. I waited. If this was an ancient black and white film rather than a colourful column you'd see me sitting on my settee as around me an old-fashioned daily calendar shed dates like a tree shedding leaves. I waited. Eventually after what seemed like months because it was in fact months there was a knock at the door. It was the postman with a parcel. I'd won! Ian McMillan: WINNER. He handed me the fragile brown cube. I was so excited I dropped it. There was the tinkling sound of shattering glass. I opened the sodden parcel. I'd won a bottle of whisky, a water jug and four glasses. The bottle and two of the glasses were broken. Still, I'd got a jug and two glasses. And I smelled like a distillery. Ian McMillan: CHUMP.

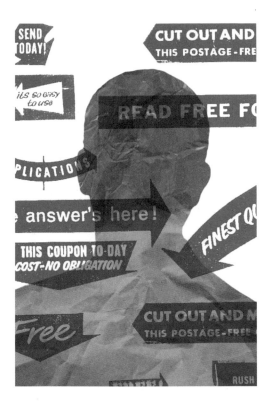

I wasn't put off. I entered more competitions. The man in the newsagent wondered why I was buying all the Barnsley Town Hall postcards he'd got and I told him. He said he'd won a three day break in Paris and a lawnmower in the last few months. This spurred me on even more. I entered.

I waited. Time passed.

Then the postman knocked again. I took the parcel, much more carefully this time. No accidents, please! The parcel felt light and soft. I tried to recall which competitions I'd entered in the last few months. Could it be the Cuddly Duck? Could it be the Stenhousemuir Scarf? Surely it couldn't be some tickets for a round-the-world trip, exquisitely wrapped? The only way to find out, as my wife pointed out, was to open the parcel. I opened it. Soft and light: one hundred Superman Lunch Bags. Marvellous. Ian McMillan: WINNER.

I didn't enter too many competitions after that.

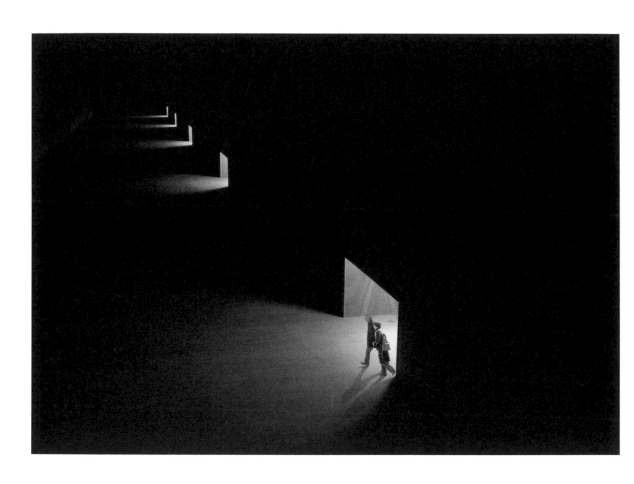

CLOSING MINE

I grew up around mines; or rather mines grew around me, below me and below my house and my school, and around and under and across the stories people told and the unspoken fears of whole streets of what might happen in some unspecified future every time a shift went down or a gaggle of men waited for the pit bus.

I grew up in coal mining country, with loads of mines on my horizon and my doorstep, names ringing like bells: Darfield Main, Houghton Main, Dearne Valley Drift, Grimethorpe, Cortonwood, Hickleton, Barnburgh, Goldthorpe.

Now, as I stroll into my half-century, they're all gone, replaced by ski slopes, supermarkets, call centres, cows grazing on grass that should be black. The mines have closed, and somehow that's become a remote idea. A mine closes like a cupboard door might close in a locked house in the next town. In other words, you don't notice.

And you should, because the language is almost too powerful: closing mine. Shutting something that belongs to me. Mine. Closing it. Closing something of me, something that belongs to me.

But now, just look at me in a mine deep in the Derbyshire hills. My mouth is as wide as the cavern I'm in. This mine closed yesterday and they've kept it open (or half open, or not quite open, or ajar, or a hint of light through a crack in the door or whatever something that's mostly closed but still open is) just for me and Helena and I'm overwhelmed.

What is this like? It's like visiting a lighthouse that's about to become automatic. It's like when I'm clearing the things from my mother's house because we're selling it because she's living in a home. It's like when I take my grandson into our shed. It's like when I'm the only one upstairs on a late night bus. It's what I imagine being a fish is like. It's like when they put your balaclava on back to front when you're a kid. It's like looking out of the window at a power failure.

There's something astonishingly moving about this, about being almost the last people to come in here; this is how it must be to be the last people in a cathedral before it falls down, or the last people in a forest just before a fire.

But no; it's more than that. The really moving thing is that this mine will be here for ages, might never get filled in, and that I might go past it in years to come and it will still be there, and somehow because I was almost the last person there, it's mine.

Mine, closed.

THE SPIRIT OF CHRISTMAS

A mini-novel for the busy teen who's too busy having Yule fun to read a conventional novel.

1. Snow.

2. Backstreet.

3. Slum. Worried parents. Child coughing. Dying.

4. Sad-faced doctor. Head shaking.

5. Goodnight doctor.

6. More snow.

7. Worried parents in bed. Cold. Too cold to sleep.

8. Thin walls. Child praying. Asking for horse for Christmas.

9. Parents distraught. No money.

10. Father goes out. Streets. Snow. Cold. Ice. Shops closed.

11. Aesthetic/Philosophical discussion
between father and local vicar on
street corner: Is God Santa?

12. Unresolved.

13. Vicar gives father a
small toy horse.

14.
Joy.
Dash.
Snow.
Slip.
Home.
Mother.
Tears.
Father.
Horse.
Bedroom.

15. Child dies. Spirit of child.
Glowing.
Through bedroom window on
white horse. Tears.

16.
Spirit of Christmas.
Vicar welcomed for
Christmas dinner.
Small duck on very big table.
Symbol. All happy.
Child in heaven. Smiling. All happy.

17. Snow.

THREE RED LITTLE RIDING PIGS

A pre-teen mini novel combining two
of your favourite stories. Hear two
at once then you'll have more time
for the video nasties.

Pigs. House. Sticks. Huff. Puff. Wolf. Big face.
See you with. Pigs. House. Straw. Huff. Puff.
Wolf. Big nose. Sniff you with. Pigs. Bricks.
House. Granny. Woodcutter. Eyes. Bricks.
Pigs. Wolf. Confused. Wolf. Identity crisis.
Wolf. Psychiatrist. Pigs. Granny. Woodcutter.
All happy. Psychiatrist is R. R. Hood.
Surprise ending.

A MINI NOVEL
For the teen who is too busy living a real
life romance to read a full-length novel.

BONUS: A choice of three endings...
 Just for fun!

DEBBIE. Sad eyes. Waitress. GRAHAM. Long legs.
Washer-up. Bad Back. Low sink. SIMON. Trim moustache.
Head waiter. Muscular neck. Debbie in kitchen. Note
in her pocket. From Graham. "Meet. 12.30. Fast car.
Elope." Note in other pocket. From Simon. "Meet. 12.30.
Taxi. Airport. New life." What to do?
Debbie. Very sad eyes. Absent minded. Customer. Paunch.
BUT I ORDERED THE STEAK! Customer. Backless Dress. IT'S
RUINED! GET CLOTH! Debbie. Eyes full of tears. What to do?
Loves them both. Dilemma as in title.

Ending 1.
 Debbie. Happy eyes. Graham. Beach. Trunks. Back better.

Ending 2.
 Debbie. Happy eyes. Simon. Cigar. Own Restaurant.

Ending 3.
 Debbie. One eye. Customer. Fork. Police. Ambulance.

SHAKESPEARE RULES BRITAIN

My nomination's curious:
A playwright long since dead
Who speaks to us from behind the veil,
Whose lines invade our head
And, more than that, dictate the way
We see and hear the world
And if this was TV now's the point
I'd get my William Shakespeare flag unfurled.

He rules the way we think
And he rules the way we speak
And on the Government front bench
There's an Andrew Aguecheek
And a Falstaff and a Bottom
And a Lady Macbeth:
We open our mouths
And out comes William Shakespeare's breath.

He rules the way we speak
And he rules the way we think;
There's Julius Caesar in your local
And his mates have bought a drink
And they're standing at the bar
And the talk's of falling kings:
It's karaoke night in Britain

And William Shakespeare sings.
Hamlet's in his office
And his emails speak of doom
And Malvolio, cross-gartered
Sits and weeps in a rented room;
And on any bus, on any train
The language of the street
Is bolted to Shakespearean Rhythms:
He's the man who keeps the beat.
I celebrate the Englishes
That permeate the air
From Europe, Asia, Africa,
But Shakespeare's still there
Like a mountain range down a country's spine
Shakespeare's a lighthouse: just let him shine!
All the world's a stage, you know,
And we all know that love is blind
And all that glistens is not gold
and we're thinking with William Shakespeare's mind.

Is this a Shakespeare I see before me,
The language towards my heart?
If the English mind's made of English verse
Then Shakespeare's a massive part!

And the rest is silence
Except for the note
Of cheering from beyond the grave
As Shakespeare gets your vote!

HE MISSED HER TRAIN:

NOTES FOR A BALLET,
PERFORMED ONCE IN A QUARRY
(JUST BEFORE A HAILSTORM)

He missed her train, and she missed his.
She ran down his platform, but her train
was on the other side of his tracks, with
him running towards her signal, her
running towards his open door, him
running to the heft of his guard's whistle,
him running to the last gasp of her
boiler's wheeze.

Ask for a copy of the

MONTHLY SUMMARY
of
EXCURSIONS
from

BRADFORD & LEEDS

Handy summary pamphlets are published
each month giving full details of excursions
to other towns, places of interest,
sporting events, etc.

ASK FOR YOUR COPY AT STATIONS,
ENQUIRY OFFICES AND ACCREDITED RAIL
TICKET AGENCIES

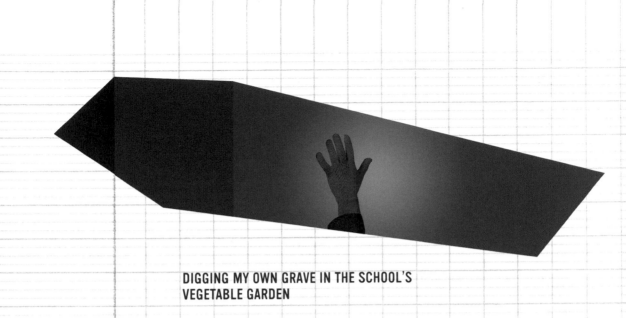

DIGGING MY OWN GRAVE IN THE SCHOOL'S VEGETABLE GARDEN

I'm digging my own grave
In the school's vegetable garden

Farewell Miss O'Brien
With the Brillo Pad legs;
Farewell Mr. Williams
Two thumbs on one hand;
Farewell Mrs. Hems
With your earrings
Like bunches of grapes;
Farewell Mr. Clay
The pottery teacher;
Farewell Mr. Nunn
Who taught us RE;

I'm digging my own grave
In the school's vegetable garden

Farewell Miss Willie
The science teacher;
Farewell Mr. Dicks
The science teacher;
Farewell Miss Longbottom
With your long bottom;
Farewell Mr. Richard Head
You were the head;

Farewell to you all
You live in our dreams
And I'm digging my own grave
In the school's vegetable garden

THE MYSTERY OF THE SHANTYATTACKER

**Sneaks up. Dark street. Moon light. Nervous walker. Always man.
Old man. Dockland street. Stooped man.**

Who has felt the whipping ocean in his face; the wind drew her map in
the corners of his eyes years ago. Long years ago.

**Moon light. Home walk. Old man. Stagger route. Beer dance. Sway
tango. Docks glint. Reflected moon.**

Like sliding down a deck it is easy for him to ease his feet down the
street's water. It is easy for him to miss the blade of the raised voice.
The shantyattacker. Hiding by the bus shelter. But waiting for no bus.
Haul away boys.

**Long shanty. Long attack. Raised voices. Moon light. Endless verses.
Endless hauling. Flailing body. Fish flail. Whale tail. Flap body.
Shanty rising. Shanty falling.**

'A death by shanty is a terrible death' Melville wrote towards the end
of his life, and he sang true. A murder by shanty involves meticulous
harmonic skill, endless choruses rising and falling like a knife might
rise and fall. And always one more verse. One more verse to make the
body twitch…

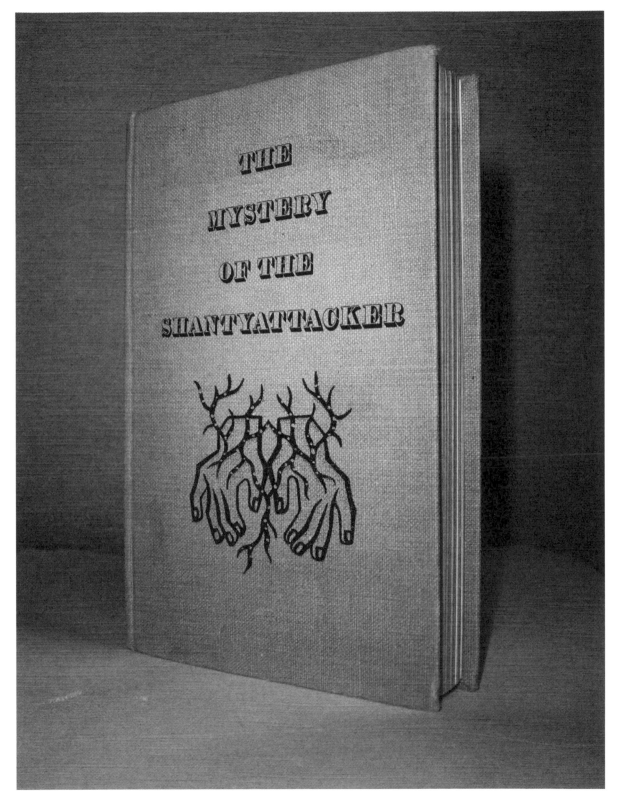

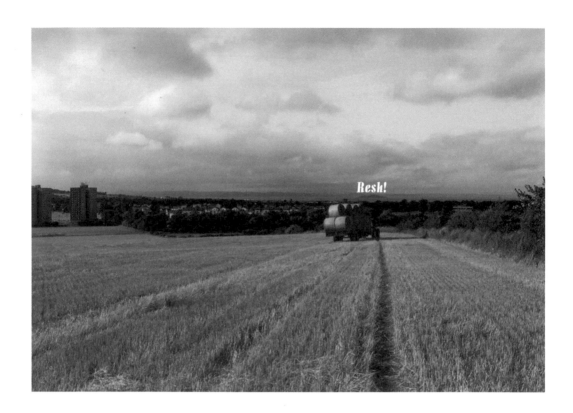

Resh!

VANGOGHSCAPE

This cornfield is making me sneeze.
The nearness of the corn to my face is making me shout **Resh! Resh!**
Like someone who only knows one word in a lost language.
The crows look like tea leaves at the bottom of a cup.
Where's the artist when you need him, with his **Resh!** with his chair and his bandage?

DEATHOFALANGUAGESCAPE

The last woman who speaks the language shouts in the language to her dead husband who speaks in no language. The words of the language hang in the air like tea leaves in a cup or like crows in a sky, although this language never had a word for crow. Or sky.

Selected lighting **50% off**

Kayo ra

INTERROGATIONSCAPE

Language is a funny thing. Language is a funny thing? You put in the question mark and up goes the voice! Up goes the voice? Up goes the voice. Can you just get that light out of my eyes? Out of my nose? Out of my head? I'm a turnip man? I hear: I'm a turnip man!

B SCAPE

Below.
Behind.
Bottles bulge.
Beneath.
Belaboured.
Bottles bumping.
Brandy, beer.
Below, behind.
Billiard balls break: blue, brown.
Brenda, Bob.
Besmirched.

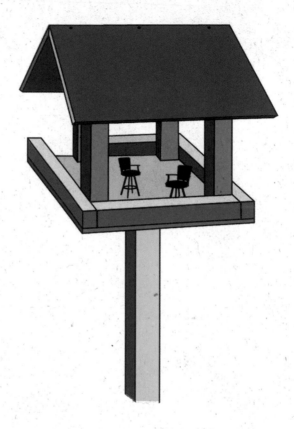

BIRDTABLESCAPE

So neat, the birdnapkins, the birdknife, the bird-
fork, the birdspoon. So 'in the right place', the
birdchairs. So delightful, the birdplacemats. So
antique, the birdnapkinrings. So out of place, the
shark's head condiment set. Here come the birds.
Seven of them, too many for the tiny table. Too
many for the crusty bread and the nuts.
The milkman calls. Runs and sits on the birdtable,
shrieking in early morning madness. How early?
That early!

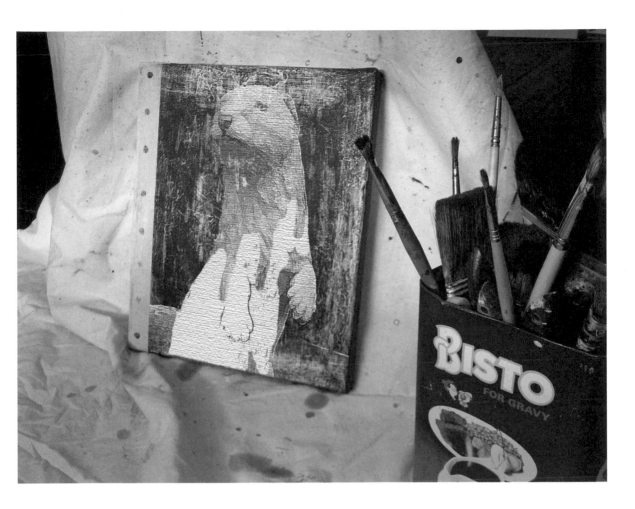

FERRETSCAPE

From this broken-down Ford Anglia I'm looking across the fields and I'm asking myself how many ferrets make a scape. In field one: six ferrets in a ragged line. In field two, the ferret boy with one up his trousers and one in his blazer pocket. In field three, a ferret sitting very still as the art class paint it. And that's it. Is that enough for a scape? I don't know. In field seventy, which is a long way away, that could be a ferret. Or it could be a bison, or a Ford Anglia. It's a dot.

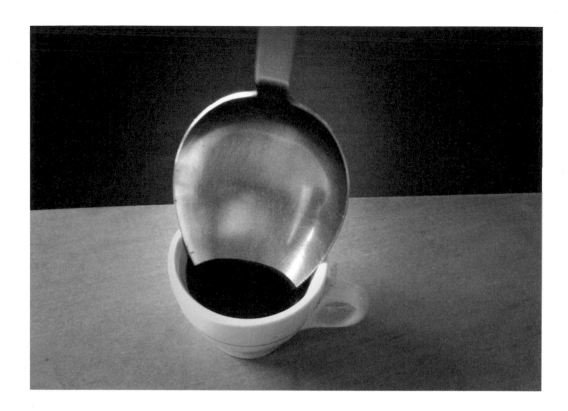

COFFEESCAPE

Like being in a quiet storm, this. The black sky.
The clouds of milk. The hail of sugar. The heat!

The Spoon of God comes to stir, so now I'm spinning like
a hair in a bath spinning towards a plughole. I'm spinning
and the black sea/sky is tilting, and now there's less of it.
That end of the world mouth is drinking it up.

I wonder whose coffee cup I'm in: Gordon Brown's?
The crossing lady from Low Valley School?
David Seaman's?
The crossing lady from Goldthorpe Sacred Heart School?
This is a good scape for thinking, for questioning.

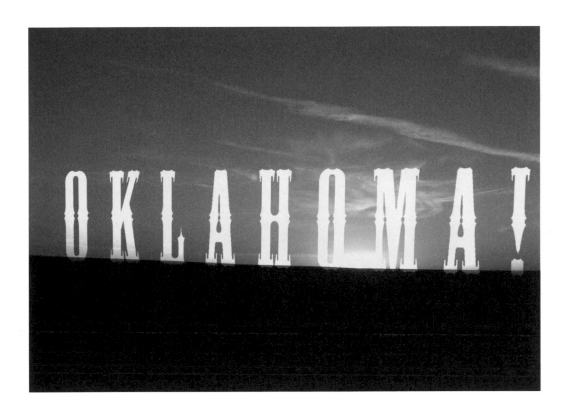

Just before curtain up the vicar came up to me and gave me some terrible news about Uncle Frank's funeral. The juggler hadn't been paid for, apparently. As you can imagine, this put me off all the way through the first act. I missed several notes. That juggler! He was good too. Although several mourners questioned the fact that he juggled naked, I have to say. Turn the tape off now, please. Please…

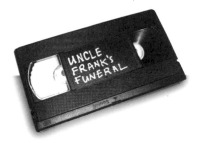

RONALD'S WORST DAY

The day he sent off for the X-Ray Spex and they sent a tiger by mistake.
Imagine the scene when he opened the parcel. He presented his little
face to the tiger thinking it was a pair of X-Ray Spex. Imagine it.
Picture it. His mother was in the cellar counting eggs. His father was at
work collecting eggs from a henhouse the size of St. Pancras Station.
The tiger! Oh, imagine it!

DEFINITE INDEFINITE

The light. The window. The tears.
The cup of coffee. The empty plate.
The light. The way the fog clears.
The calendar. The November page.

The trees. The leaves. The falling.
The old car. The way it steers.
The silent phone. The nobody calling.
The weeks. The months. The years.

A lonely time and a waiting game
A day that's just the same
As a day I've had before
And a day I'll have again

ODDLY LYRICAL NEWS ITEM

Louth, Tuesday

After a freak storm two lollipop ladies from opposite ends of the county were deposited unharmed in the same field near Louth yesterday morning. The owner of the field, Mr. Frank Giles, said 'I just looked up and there were two lollipop ladies in my field. Of course I stopped my tractor straight away.' Lollipop lady Josie Breen, 47, said 'I was thinking about my holiday in Lanzarote when suddenly I thought I was taking off early!' Lollipop lady Kath Stevenson, 39, said 'I just held on to my lollipop and that's about it really.'

THE PHILOSOPHER SPEAKS

I dropped my watch in the mud therefore I did
not know what Time it was therefore Time itself
stopped therefore the world itself slowed to a halt
therefore the Universe stopped spinning. Because
Time had stopped the dropping of my watch
happened in a fragment of the Space / Time
continuum outside time, a fragment we shall
call Kip. Therefore the mud did not exist and
therefore the watch clattered onto the hard
concrete floor at the edge of the old laundrette.
Mrs Flanagan: she ran the laundrette. I often
heard her singing the old Shropshire Songs when
she thought she was alone.

The day I lost my lucky rupee was the day I fell from the steps as I attempted to get something from a high shelf.

It was also the day the nail went through my foot.

It was also the day my winning lottery ticket...

Oh, who am I kidding ? I never had a lucky rupee! I've never even been to Portugal!

I never had a lucky rupee! I'm just unlucky!

Yes, laugh!

Laugh at the hopping of the man with the nail through his foot!

I never (SOBS, ALMOST BREAKS DOWN)

had a lucky rupee!

give

MY COUSIN
CAME FROM LIMERICK

Each morning he'd walk down the street
with a pair of pink shoes on his feet.
When people asked why he was moved to reply
'I think that this footwear is neat!' But that didn't
tell the whole tale: the fact is he whiffed bad of ale.
He stunk like a barrel in his beery apparel like a vagrant
just chucked out of jail. And yet those pink shoes
gave him class, like a sunset illumines a pass that's
otherwise dull in the Mountains of Mull or the shale
cliffs just south of Cwmglas. Those pink shoes
gave my cousin fame, they made sure you remembered
his name. He's been dead fifteen years. Folks recall
him with tears, saying 'With those pink shoes he was,
assuredly, ahead of the philosophical and linguistic game.'

103

I VISITED HER ON SUNDAY

I visited her on Sunday and she insisted that it was Monday.
I said no, it's Sunday and she said No, it's Monday. I sulked.
Sunday, I said. Monday she said. Sunday I said. Monday she said.
We argued for a day. And it was Monday. Now it's Monday, I said.

And you can guess the rest.

The way the argument went on and the days changed and we
were always one day behind and one day in front, one day ahead
and one day behind.

This went on for fifteen years.

Then I had a phone call from my wife. 'You've been away for
fifteen years' she said, her voice rising and oddly Welsh. 'Did you
manage to find the cauliflower? Dinner's ruined anyway.'

Those fifteen years were the best of my life, in many ways.

THE BEARS WHO SAILED AWAY

You all remember the story of The Bears Who Sailed Away, so I have no need to go over it this afternoon. But the mystery of where the bears sailed to has never been satisfactorily answered. I think the clues are in the story. You have your texts there, so if you turn to page 37 you will see the line 'Samuel Bear asked about the hoover.' Hm? does this not give us a clue, a pointer? How about page 94: 'The sun set slowly in the West as the bears sailed on.' In the West: do you see, Ladies and Gentlemen. In the West. Hm? The West.

A bell rings. Chairs scrape.

So there is your assignment. 'Where did The Bears Sail to?' By next Monday, please. Don't forget:
I shall be starting the lacrosse club again from this Thursday.

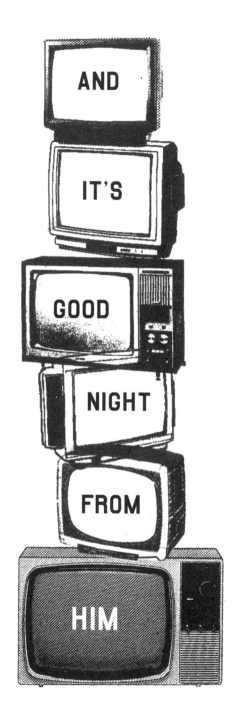

It's goodnight from him
and it's goodnight to this:
Saturday bathtime, a home win,
the bliss
of a night in the glow
of a rented TV;
a family spread out
on two chairs, one settee.

It's goodnight from him
and it's goodbye from me
to a comedy built on dances with words,
an eye for the language
an ear for absurd
interlocutions, grammatical fluffs
and lines that my brother just called
'sentence stuff'
but it made us all howl
and that was enough.

So it's goodnight from him
and goodbye to a time
when Saturday night
clicked round like a rhyme
in the kind of odd song
Ronnie Barker might croon
and the words made you smile,
but they fitted the tune
like the bloke in the glasses
with a face like the moon
fitted Saturday night;
it was over too soon
but it kept us all laughing
while outside the world
was changing and shifting
he cut through the gloom:
the comedy furniture
in our collective front room.

The following texts first appeared:

Song Of The Quarryman, Sky Altering Time, Closing Mine:
 Industrial Relations by Helena Ben-Zenou, Derbyshire Community Foundation, 2006
Elvis Presley: *New Musical Express*, 1983
Mini-Novels: *New Musical Express*, 1983
So He Went Searching: *Further Up In The Air*, Liverpool, 2003
Chess Column: *The Message*, BBC Radio 4, 2005
Endless Shedness: The Shed, Malton, North Yorkshire, 1997
Cornish Cliffs Revisited: *The Today Programme*, BBC Radio 4, 2005
The Mystery Of The Man With His Own Sea: *The Sea, The Sea*, BBC Radio 3, 2005
Shakespeare Rules Britain: *The Today Programme*, BBC Radio 4, 2005
Digging My Own Grave In The School's Vegetable Garden: *Mark Radcliffe Show*, BBC Radio 2, 2006
Goodnight From Him: *Front Row*, BBC Radio 4, 2005

Photograph page 16: angiescarr.co.uk
Painting page 67: Thanks Dad
Photograph page 101: bigfoto.com
Ian McMillan jacket portrait: Jeremy at Jaded

WORDS Ian McMillan
PICTURES Andy Martin

DESIGN Murray & Sorrell FUEL